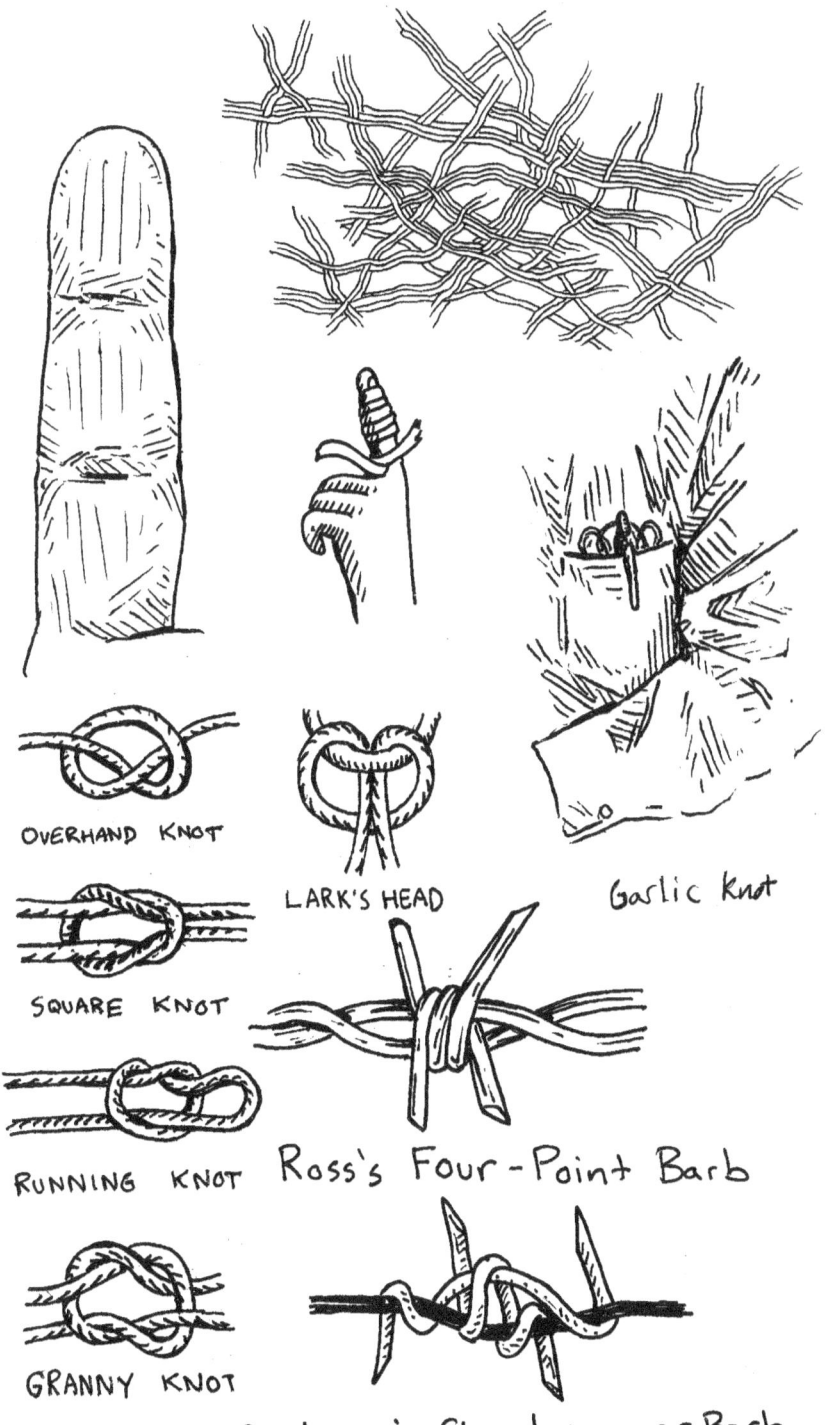

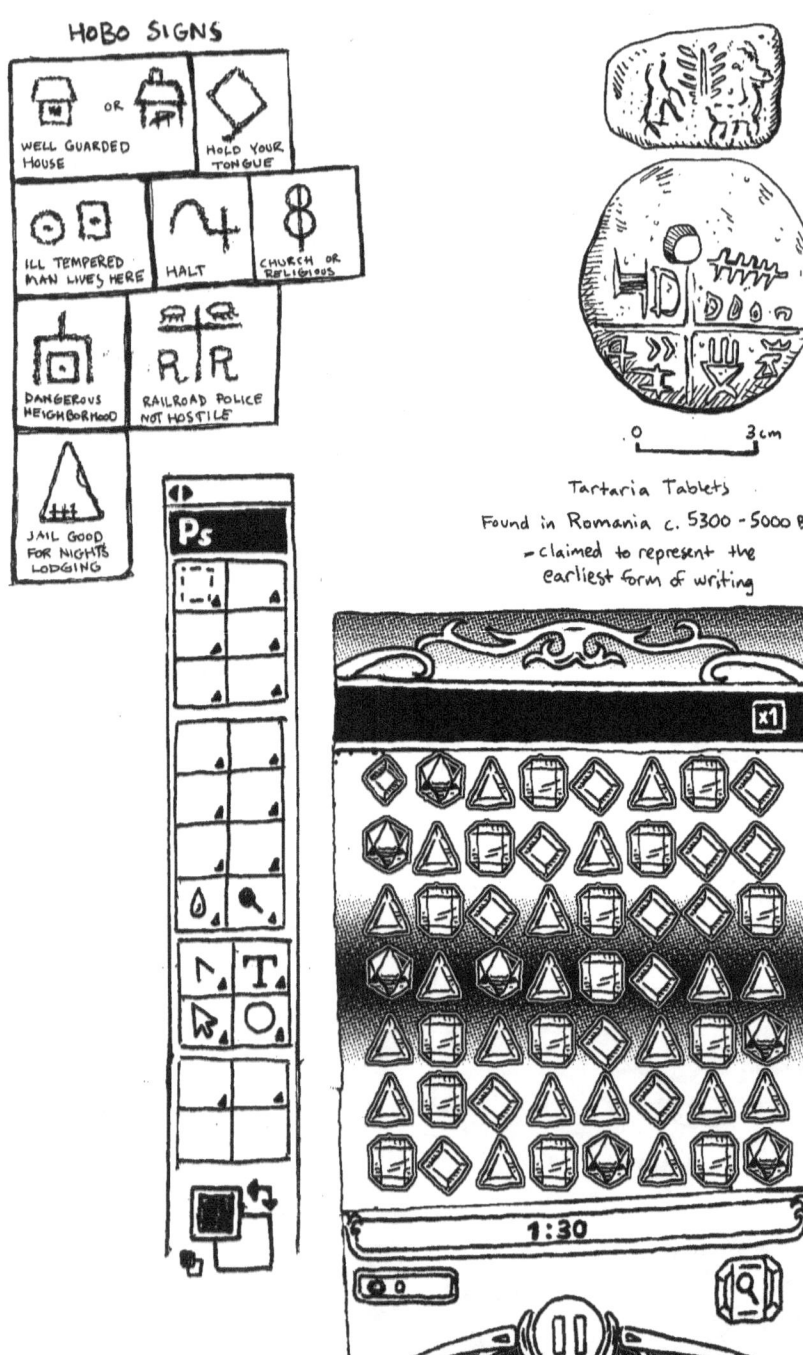

HOBO SIGNS

- WELL GUARDED HOUSE
- HOLD YOUR TONGUE
- ILL TEMPERED MAN LIVES HERE
- HALT
- CHURCH OR RELIGIOUS
- DANGEROUS NEIGHBORHOOD
- RAILROAD POLICE NOT HOSTILE
- JAIL GOOD FOR NIGHTS LODGING

Tartaria Tablets

Found in Romania c. 5300 - 5000 B.C.
- claimed to represent the earliest form of writing

DUHH...VINCI

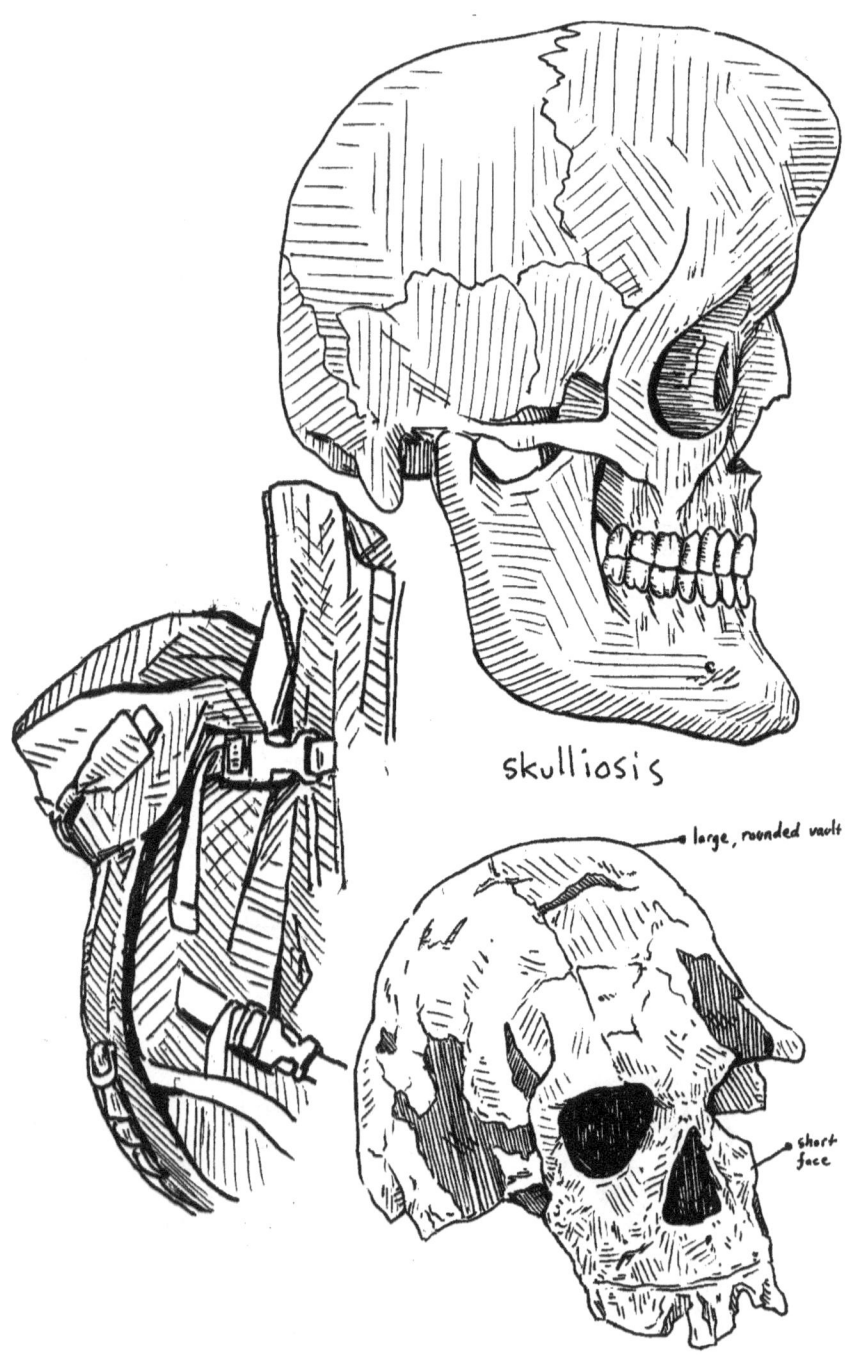

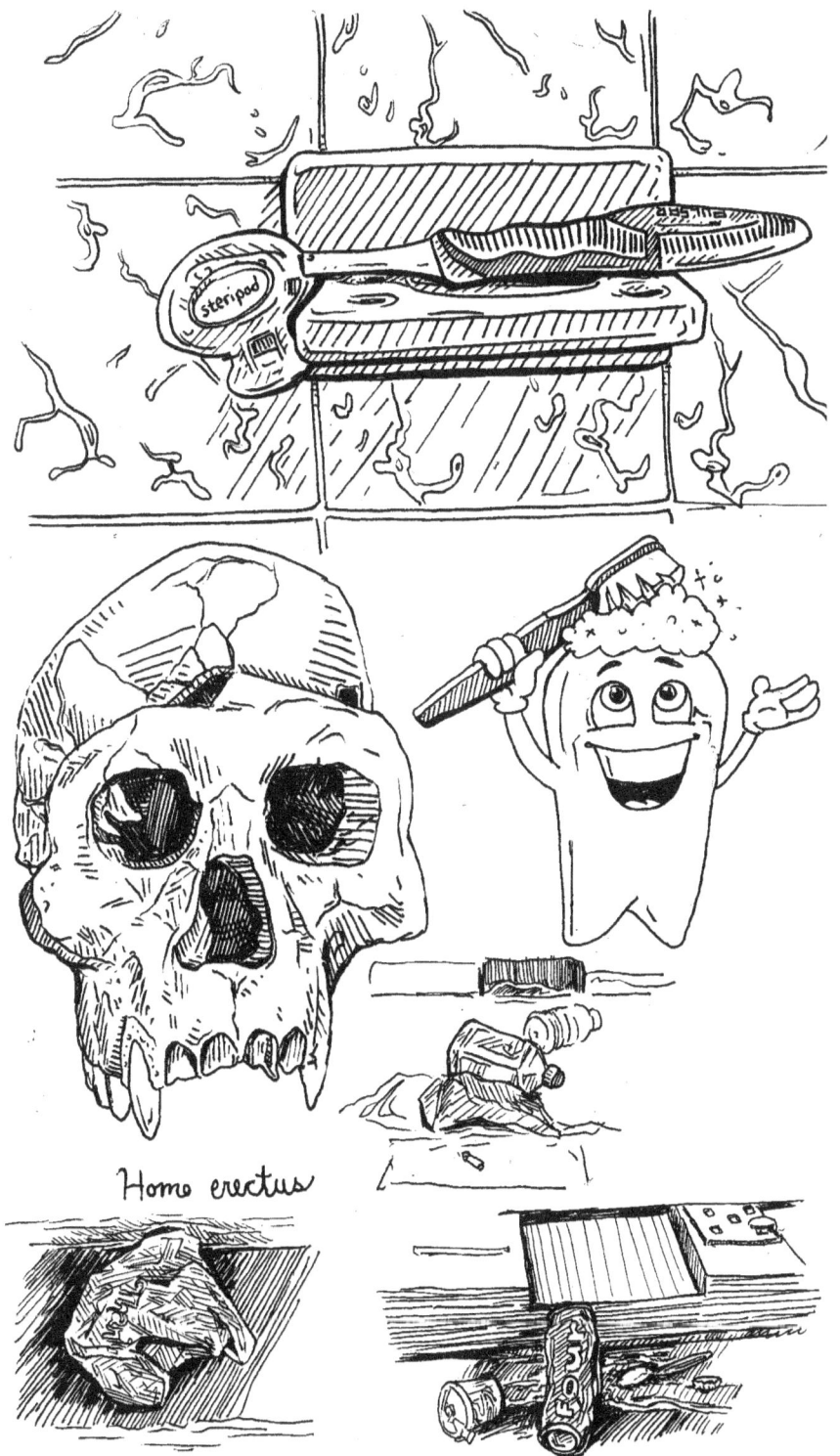

A Copy of a drawing by H. Cardanus
Paris 1658

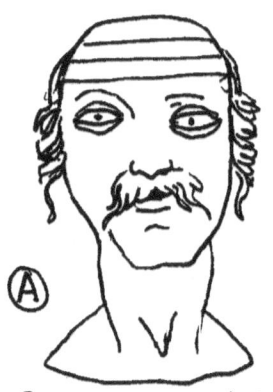

(A) Brow of a peace-loving and successful man.

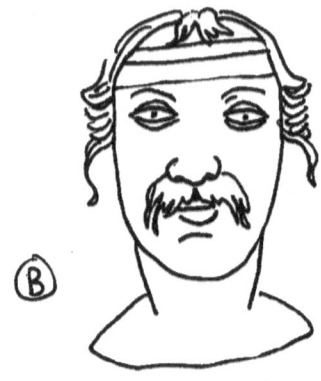

(B) Brow of a spiritual man w/ an inclination towards priesthood.

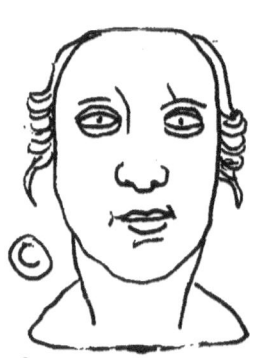

(C) Brow of a man who will die a violent death.

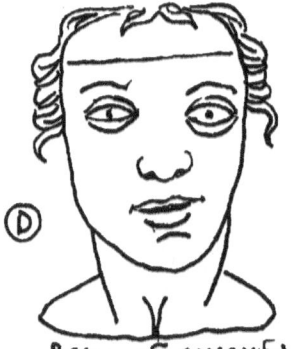

(D) Brow of successful soldier.

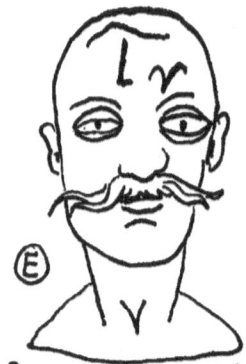

(E) Brow of a man threatened by an injury to the head.

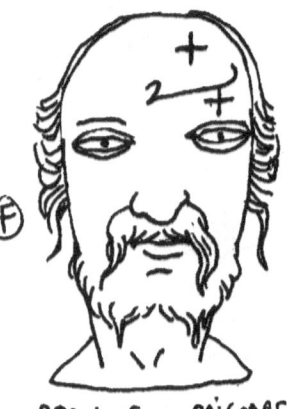

(F) Brow of a poisoner

seville orange
(citrus aurantium)

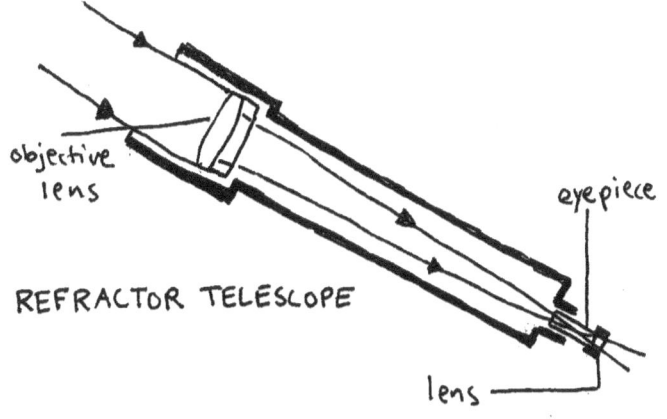

REFRACTOR TELESCOPE

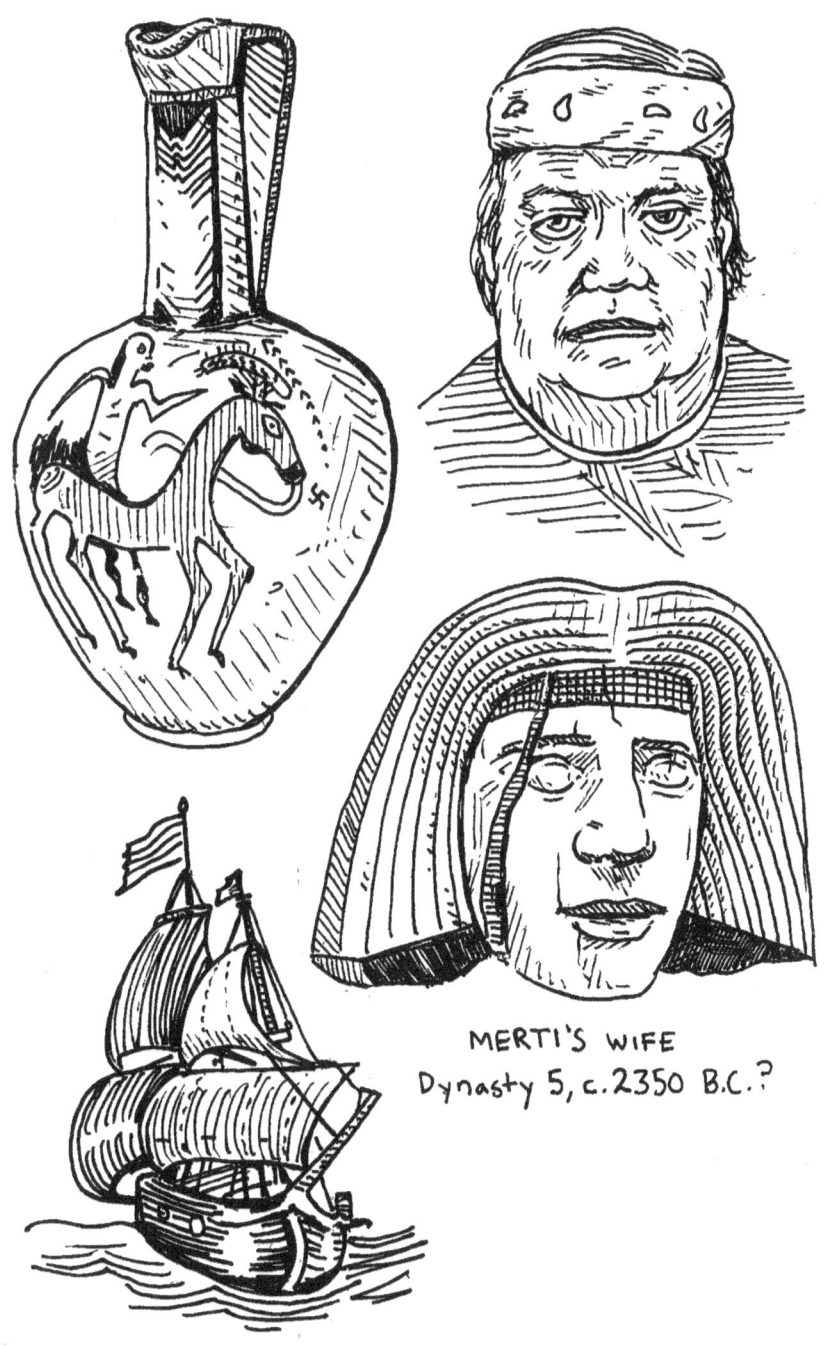

MERTI'S WIFE
Dynasty 5, c. 2350 B.C.?

The Faculty held contemporary art in contempt.

People with a MASTERS of FINE ART trying to turn their "F" into a "B"

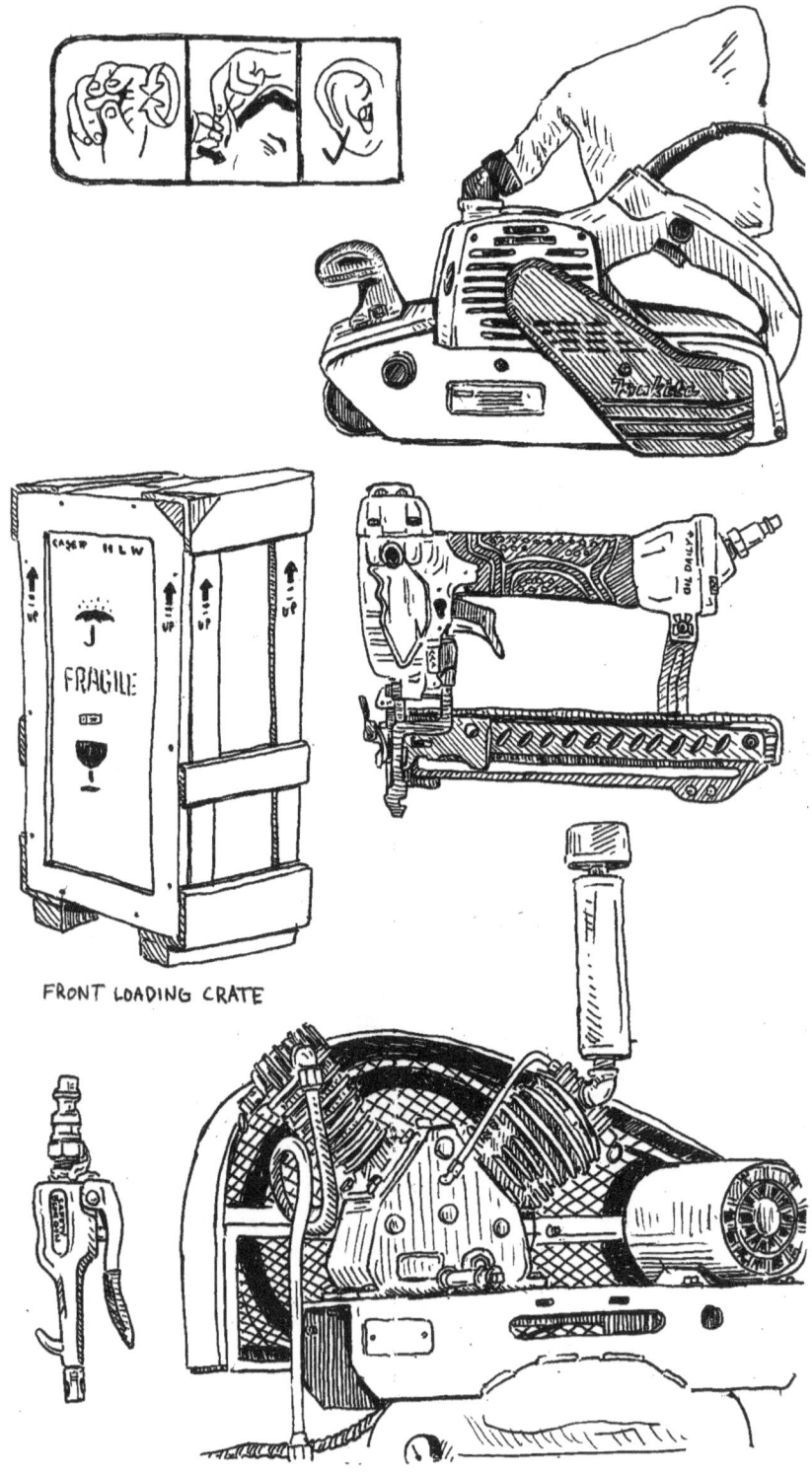

FRONT LOADING CRATE

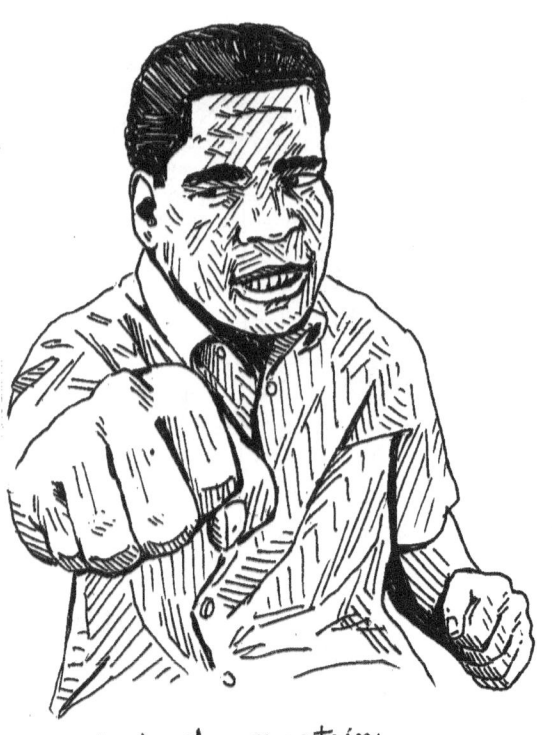

It isn't the mountains ahead to climb that wear you down. It's the pebble in your shoe.
~Muhammad Ali

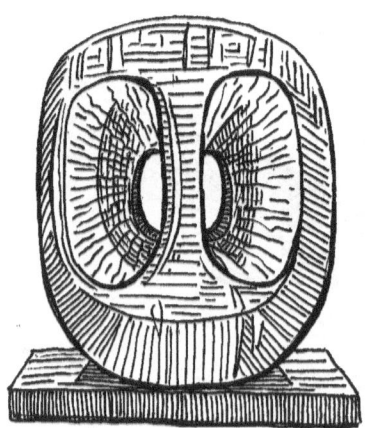

Hollow Form with White Interior
Barbara Hepworth 1963

It's not whether you get knocked down, it's whether you get up.
-Vince Lombardi

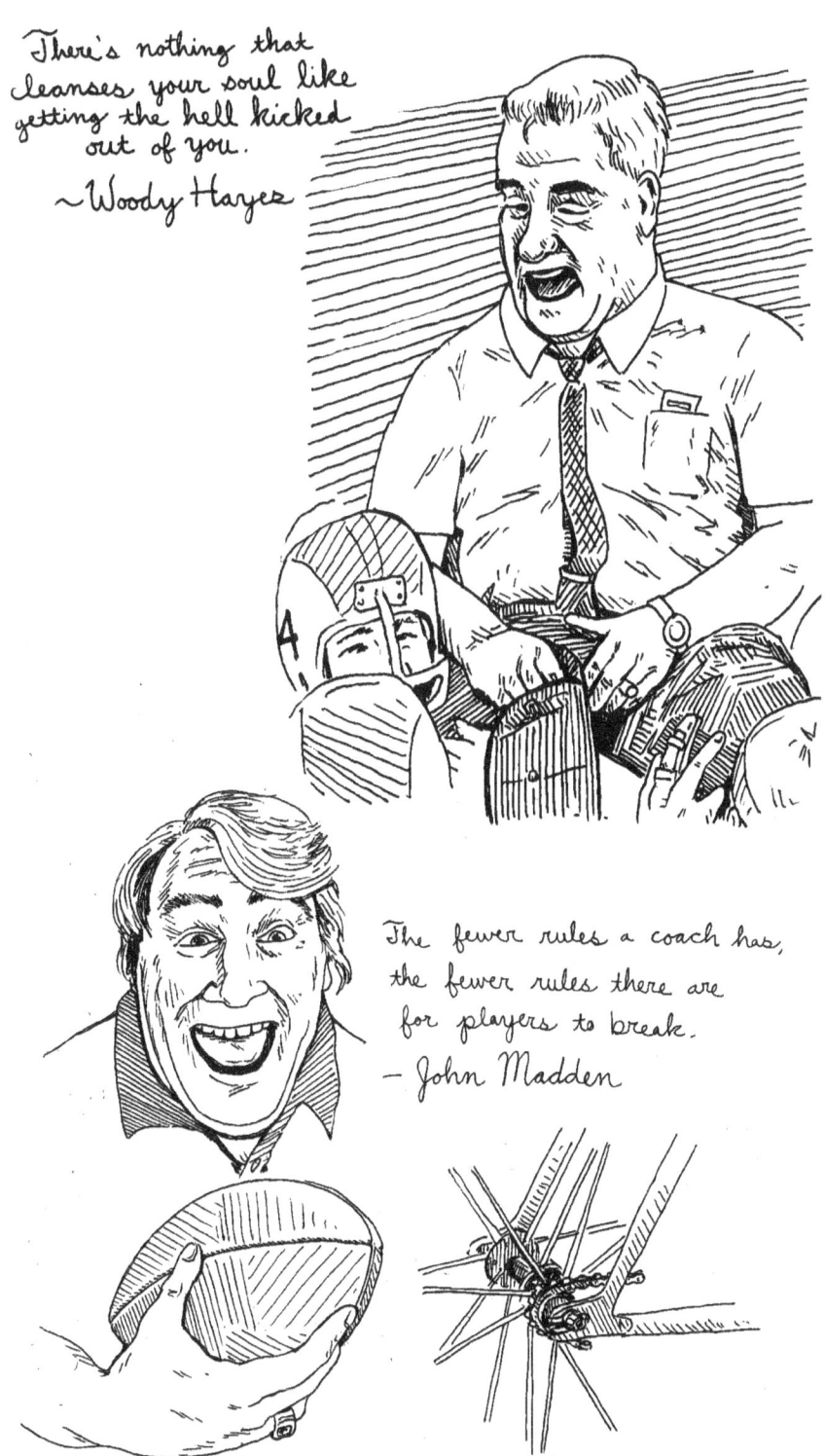

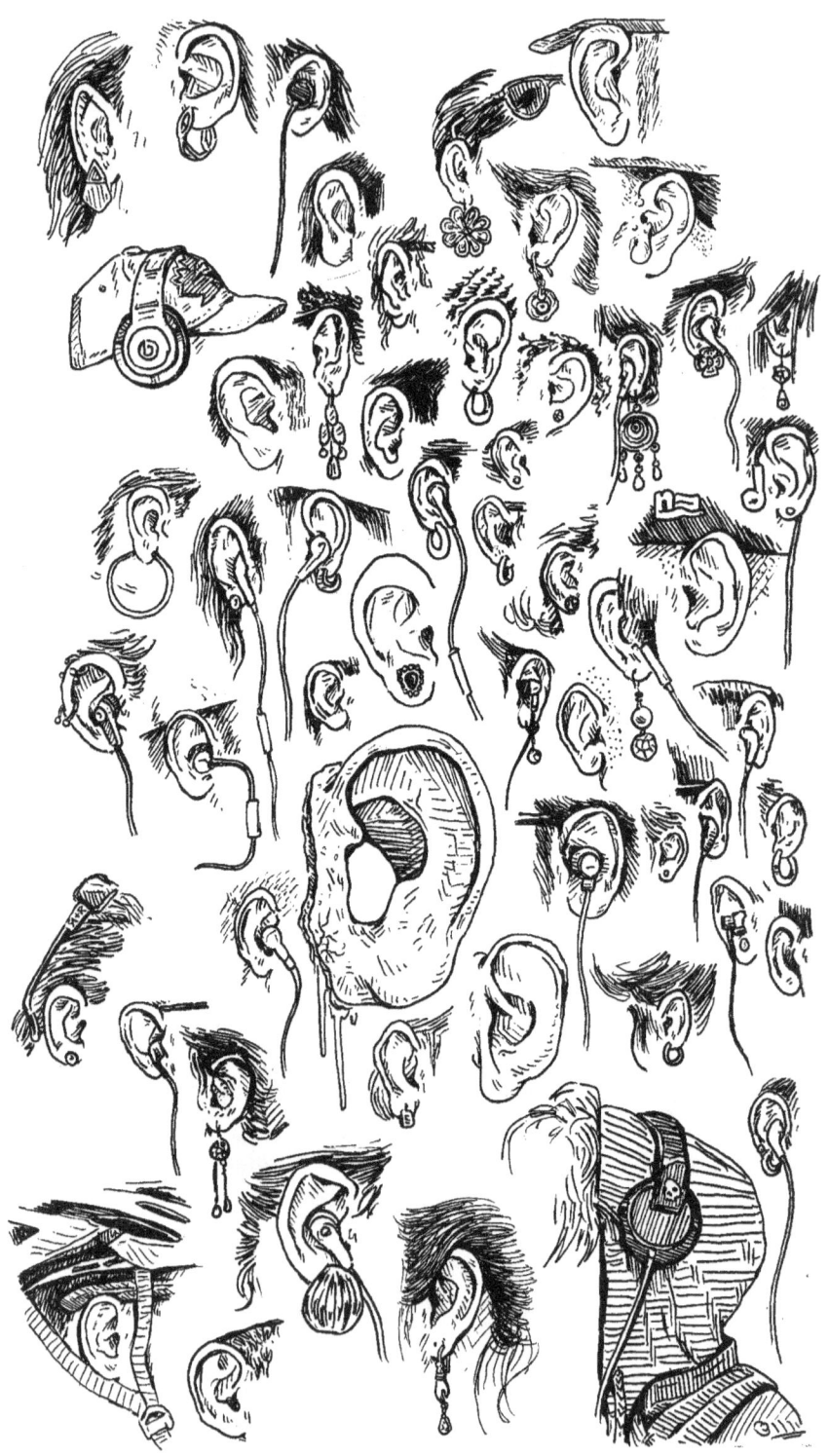

I'm ALL EARS

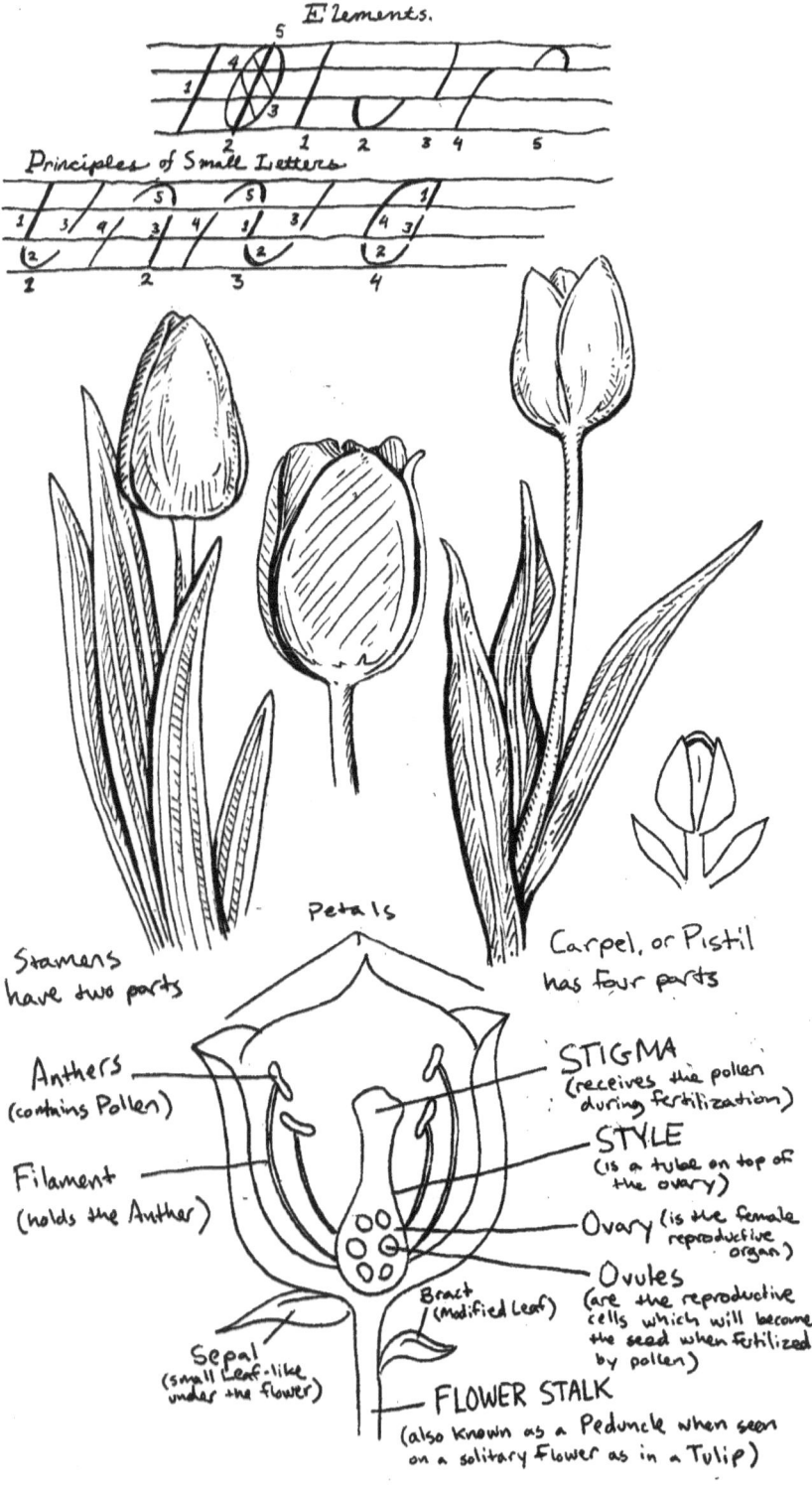

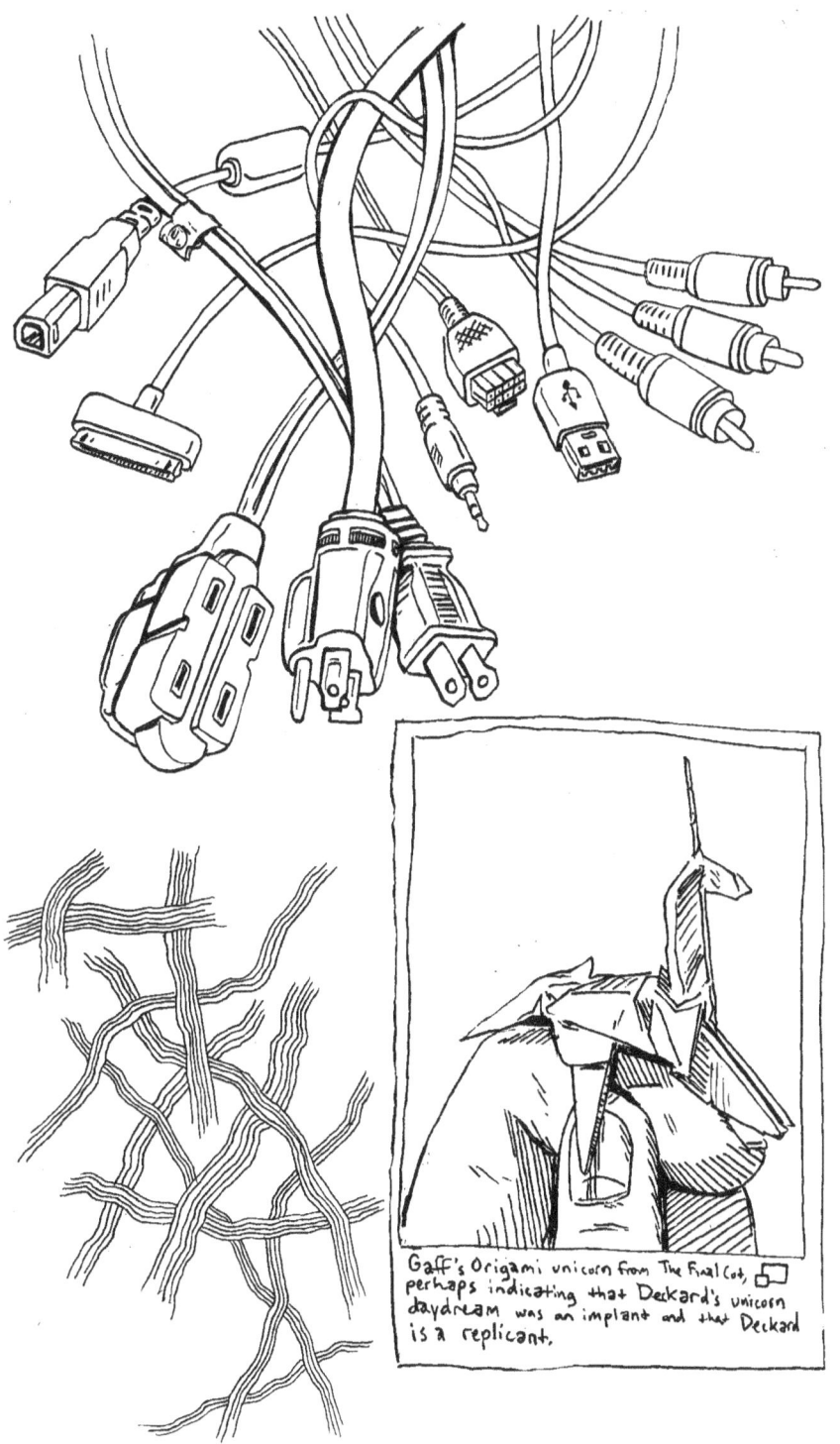

Gaff's Origami unicorn from The Final Cut, perhaps indicating that Deckard's unicorn daydream was an implant and that Deckard is a replicant.

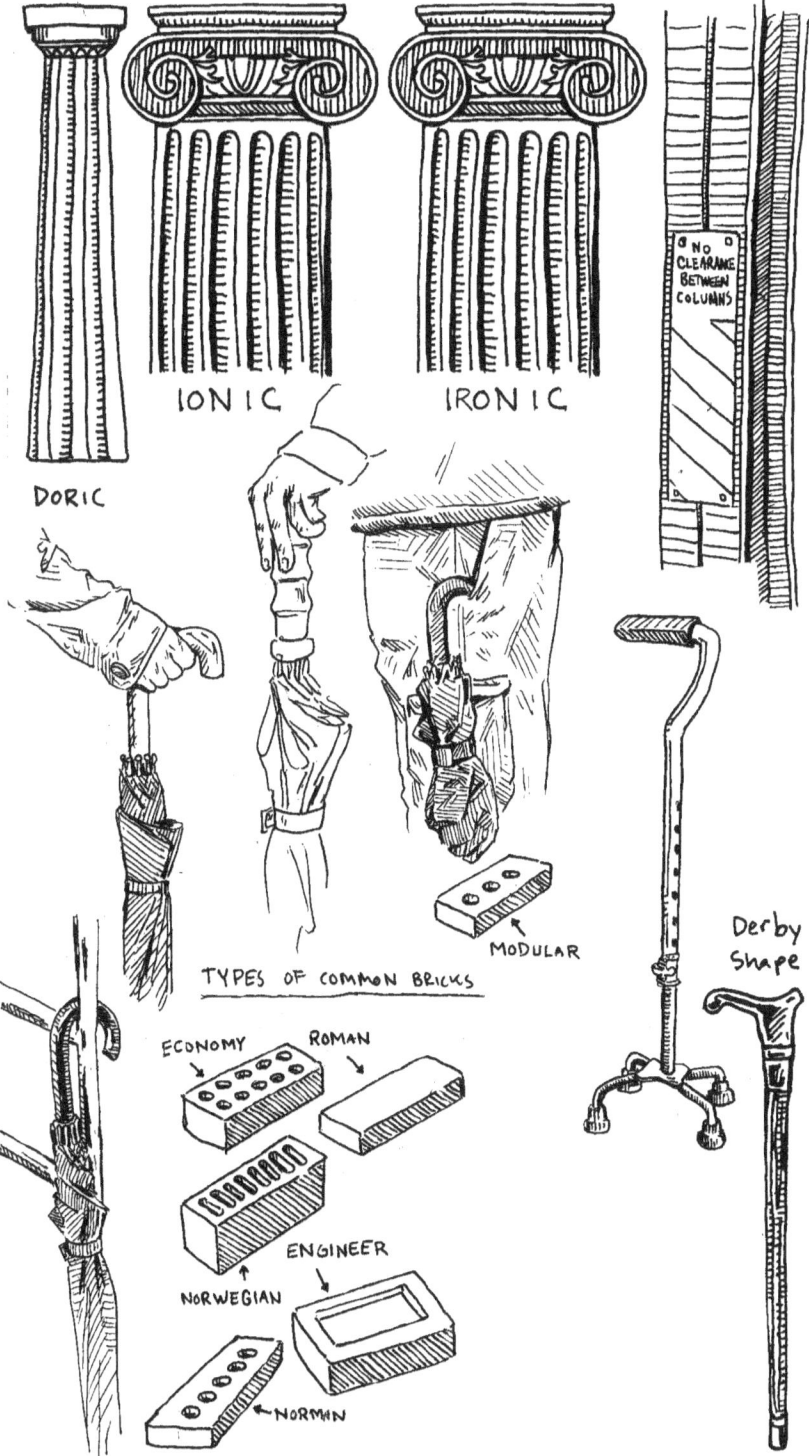

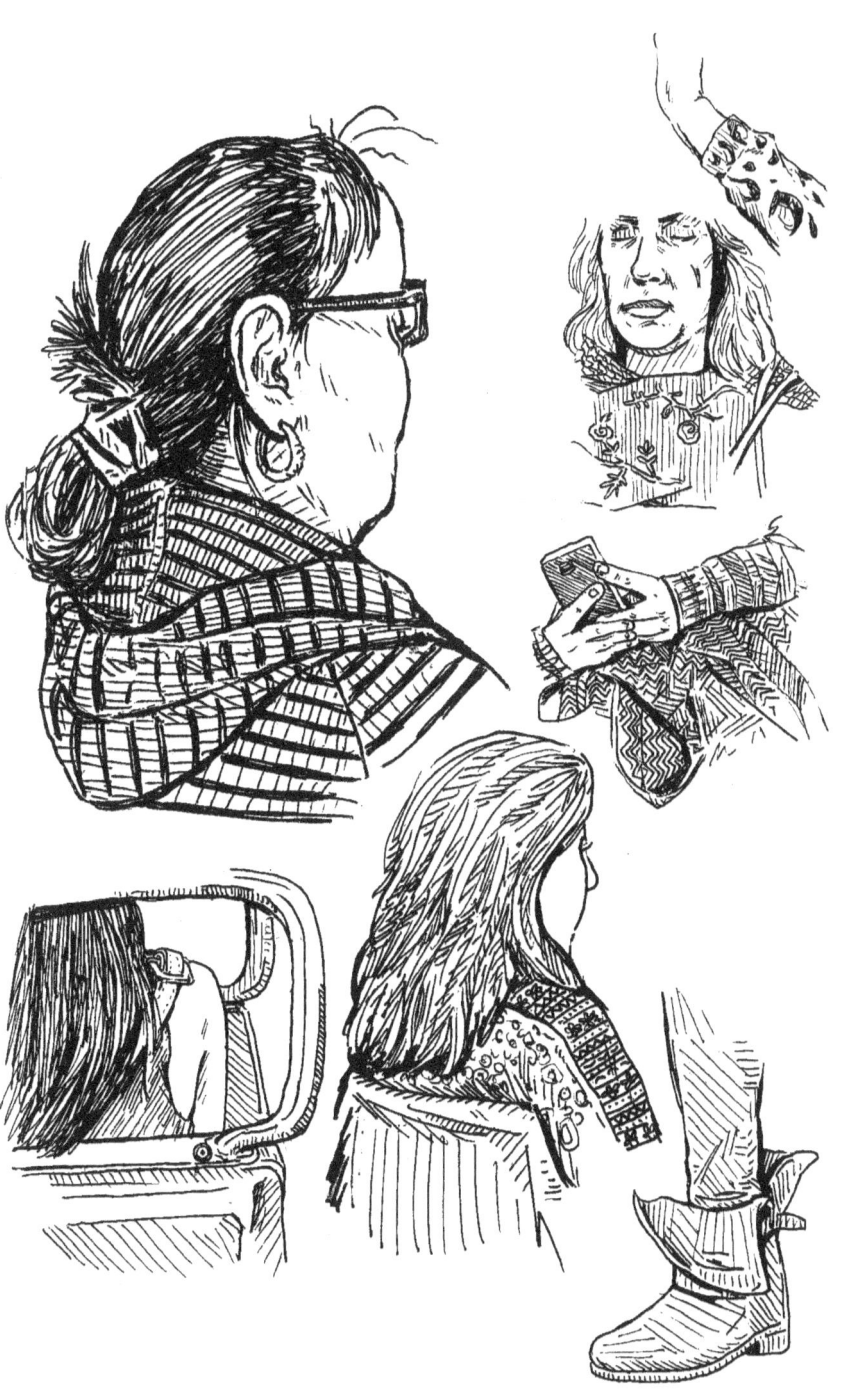

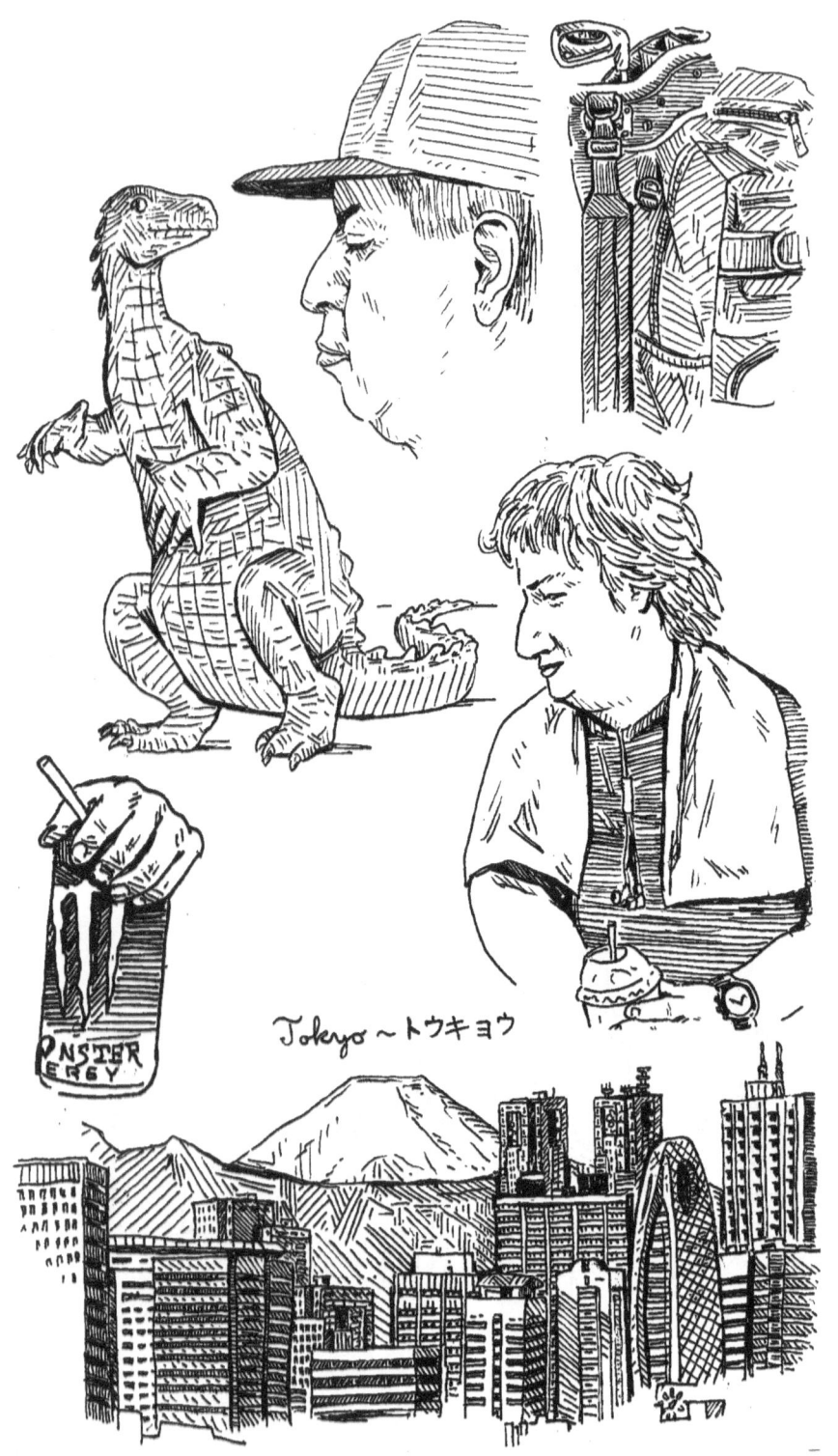

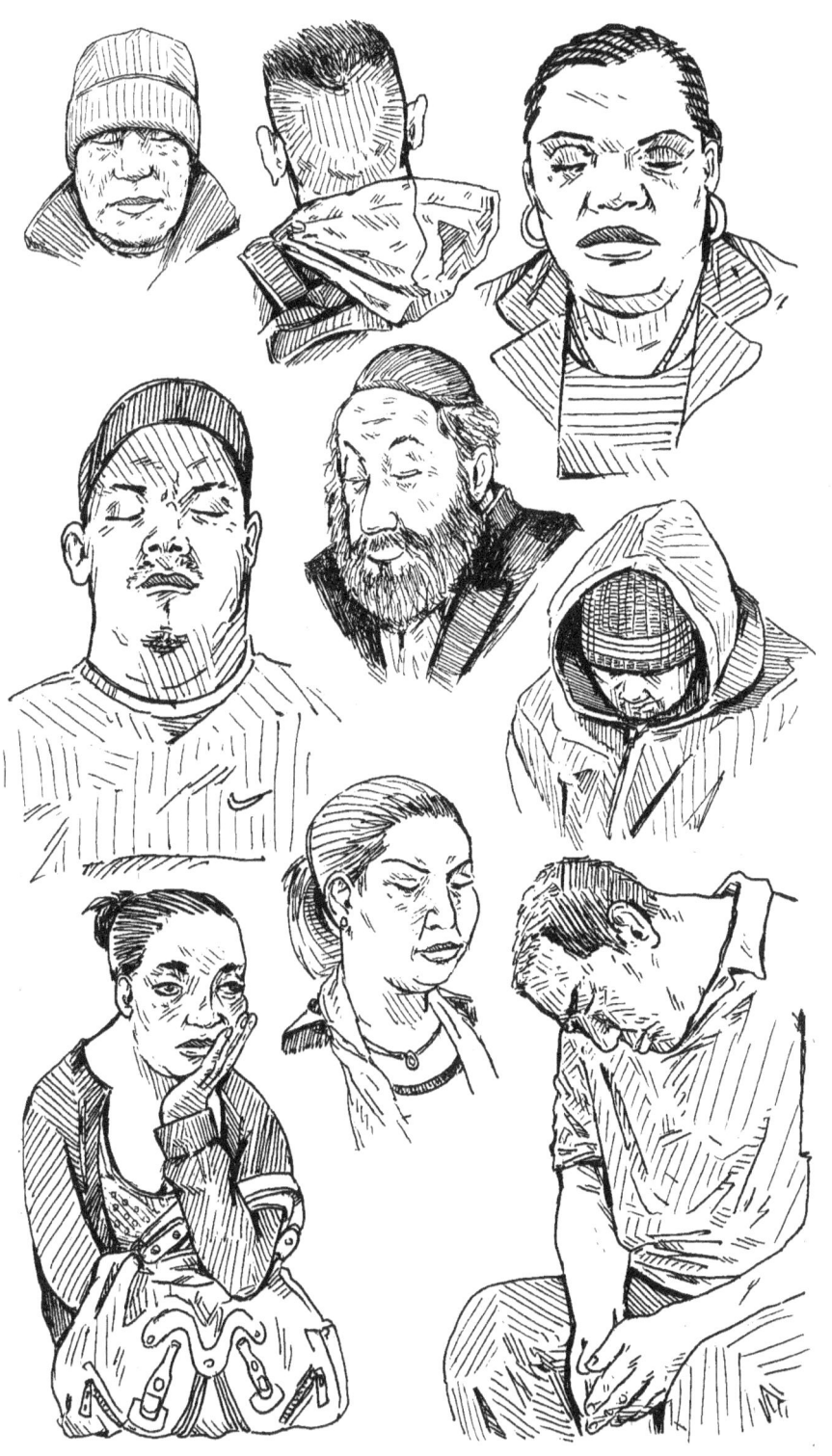

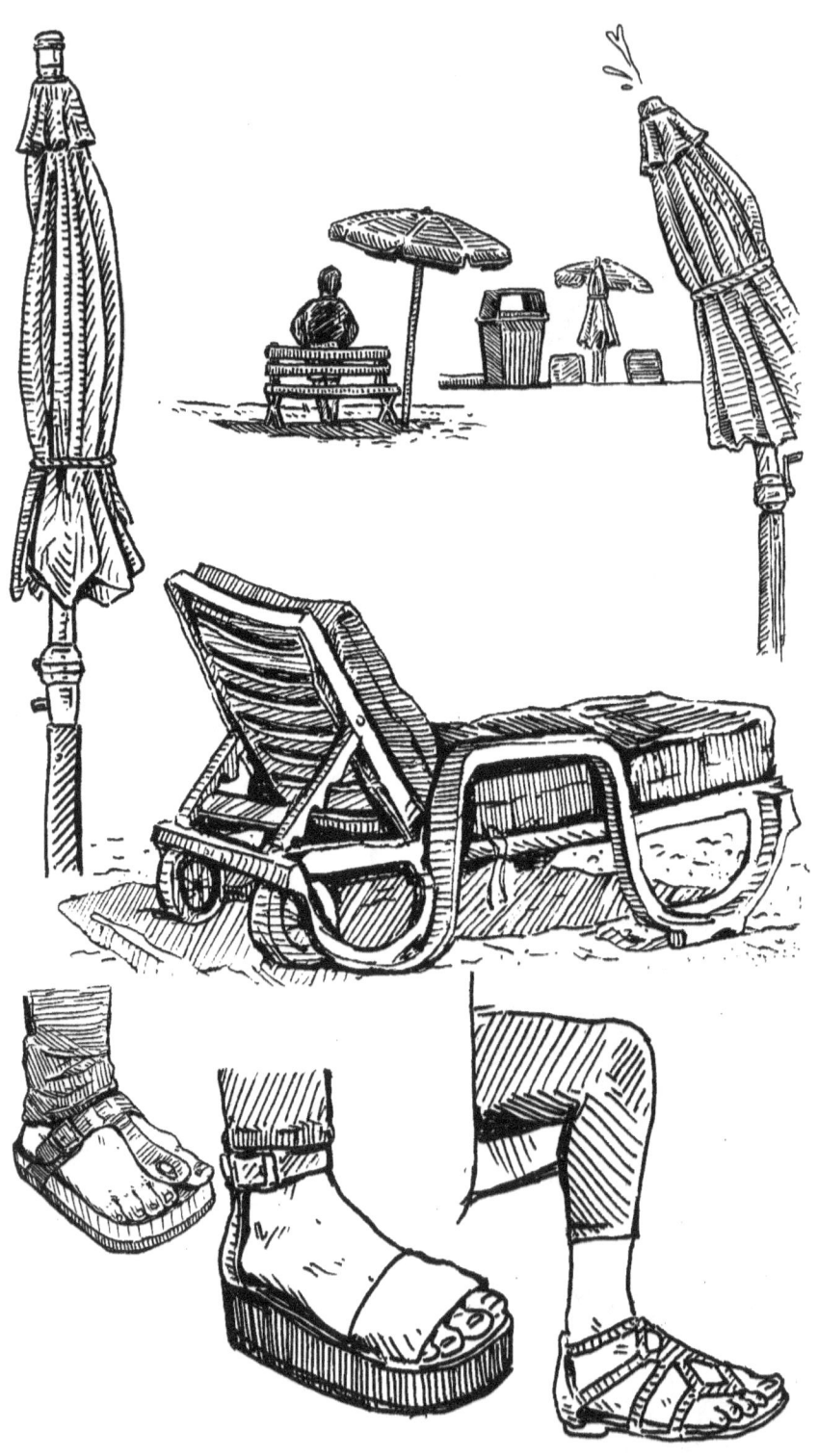

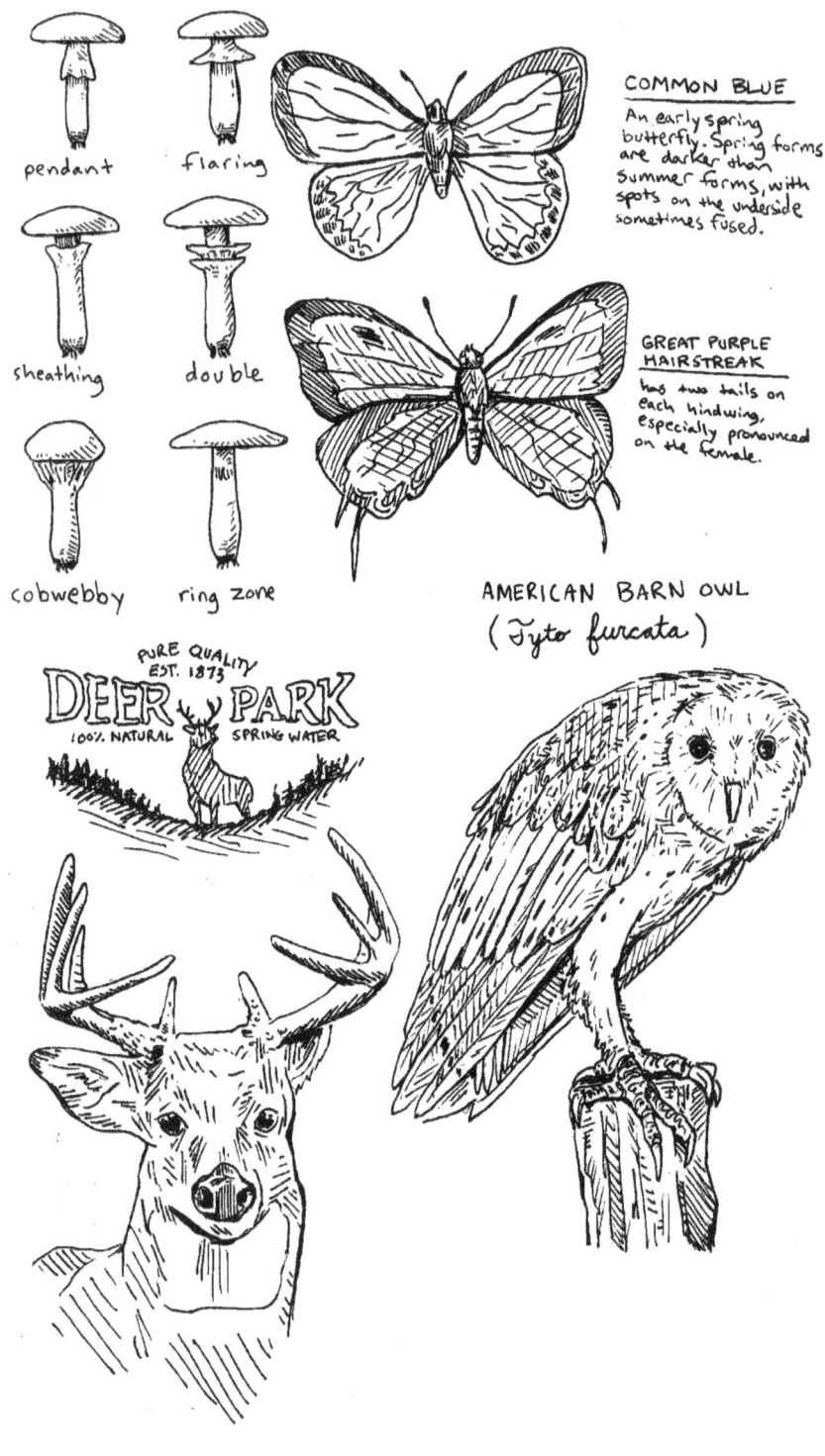

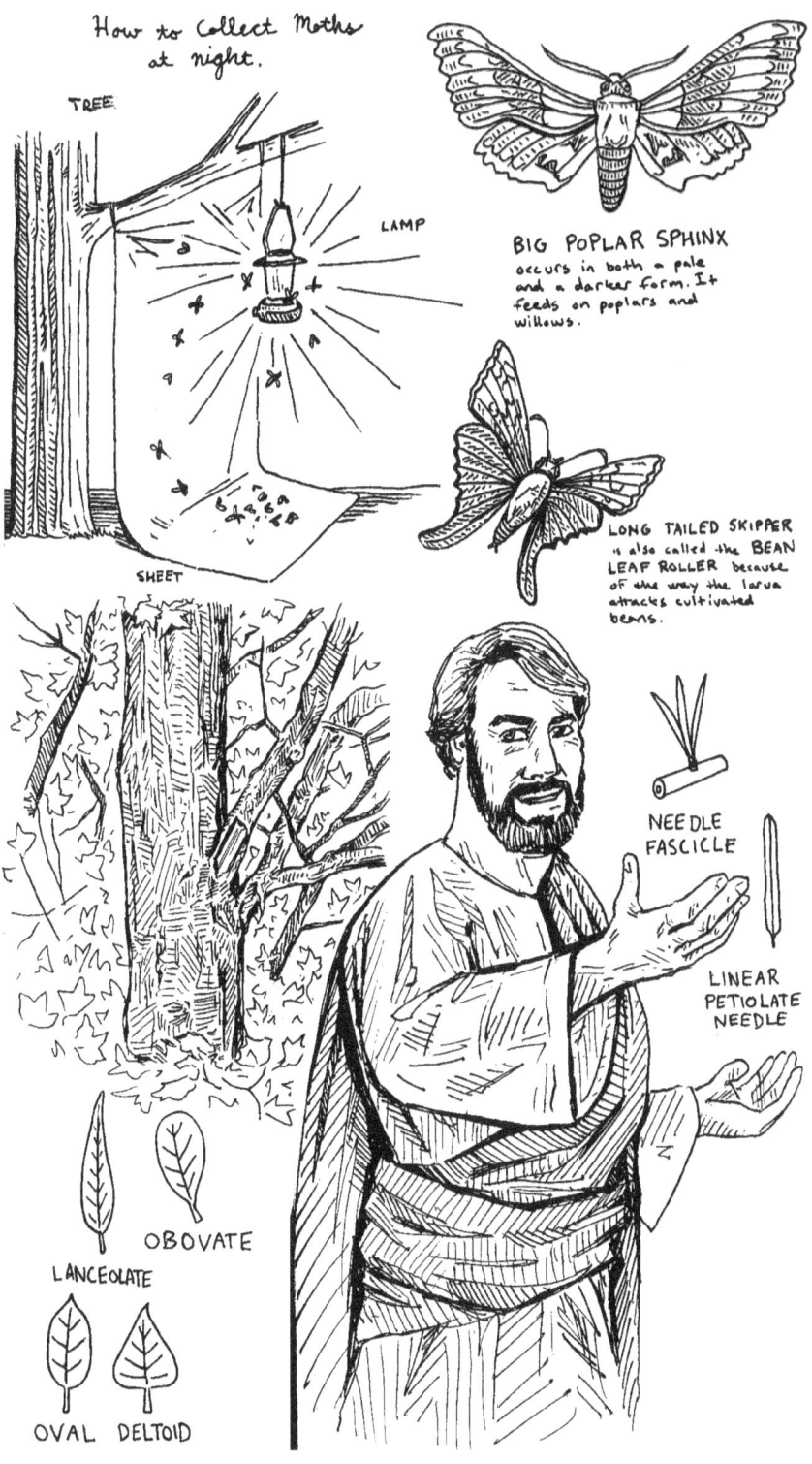

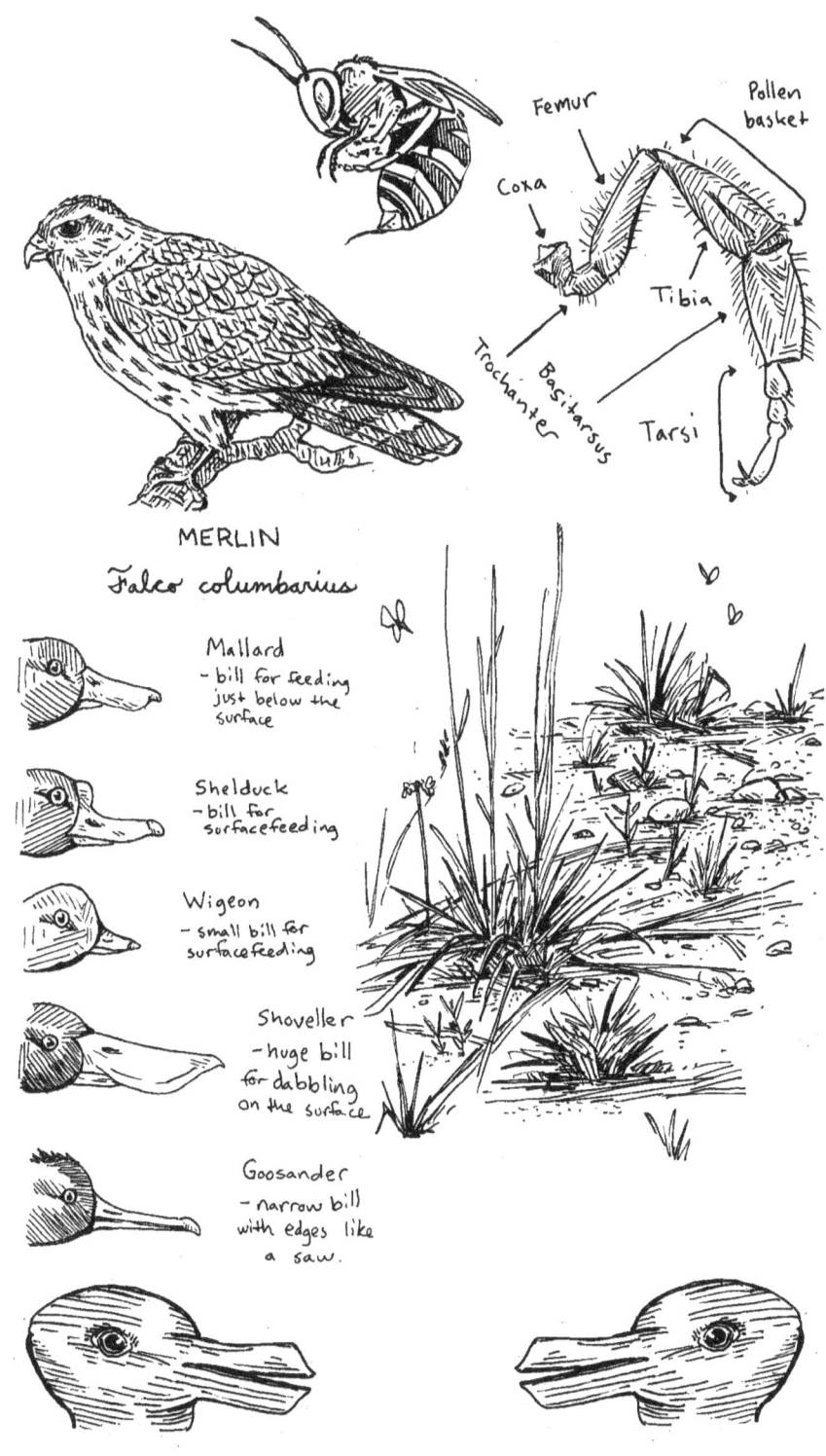

Weaver Ant

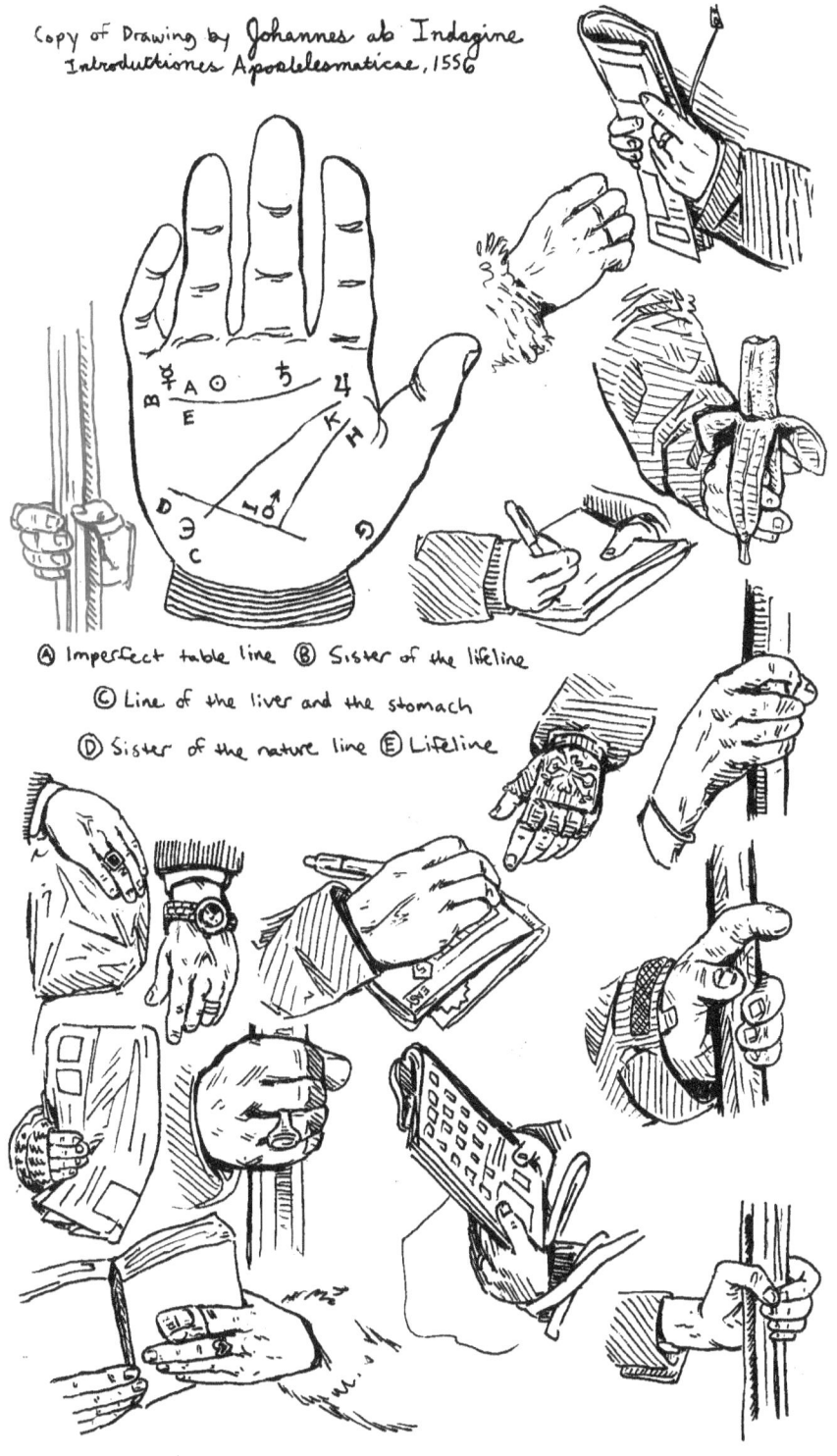

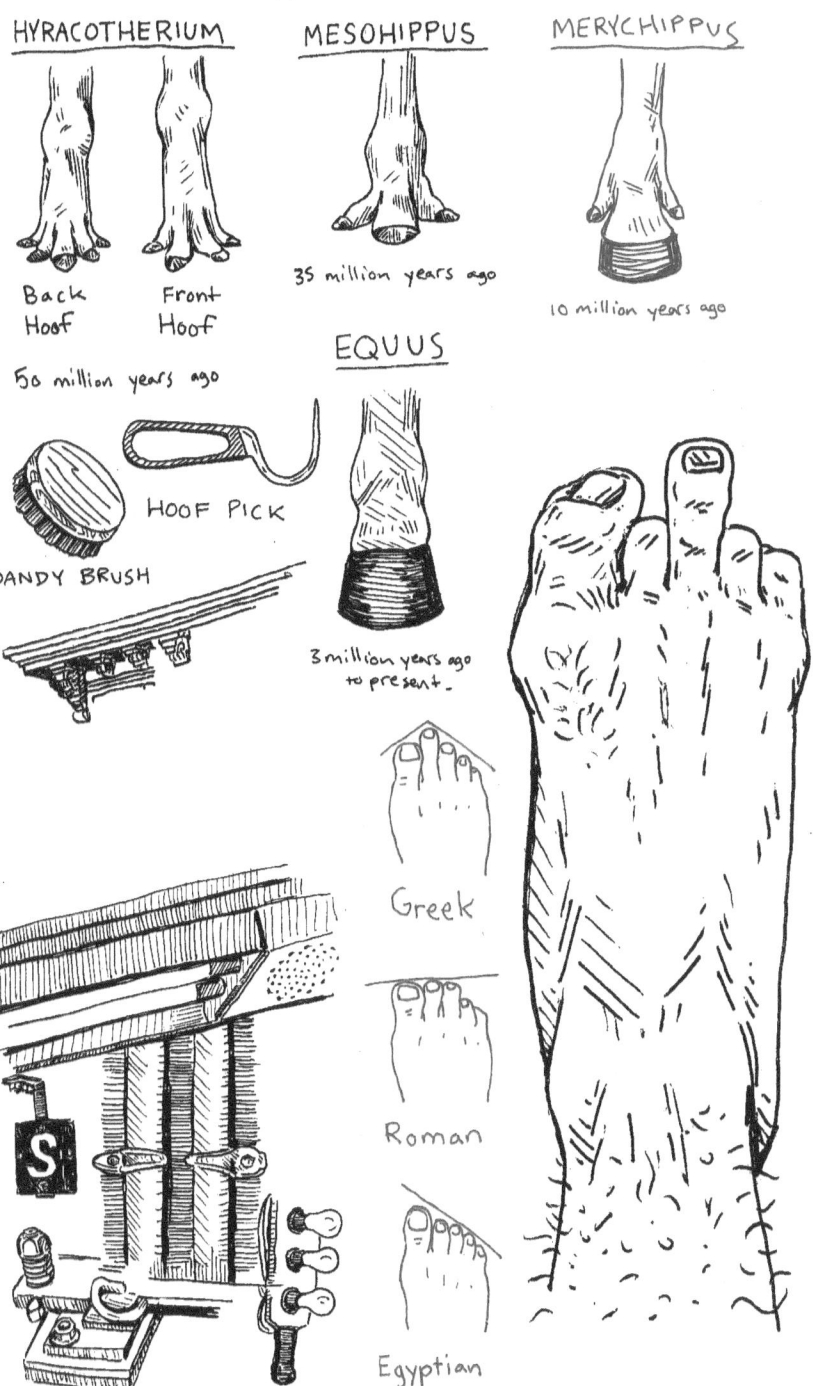

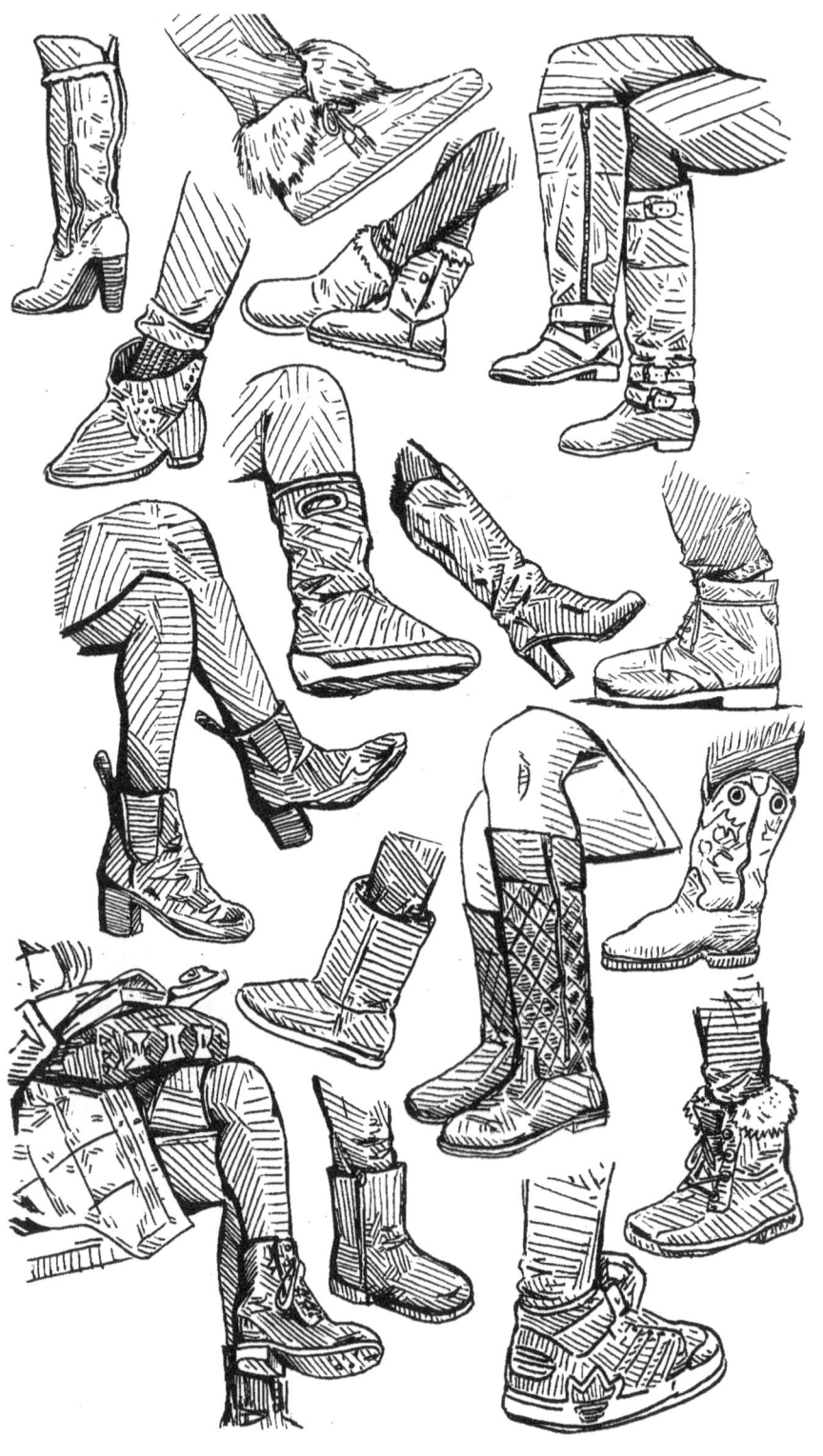

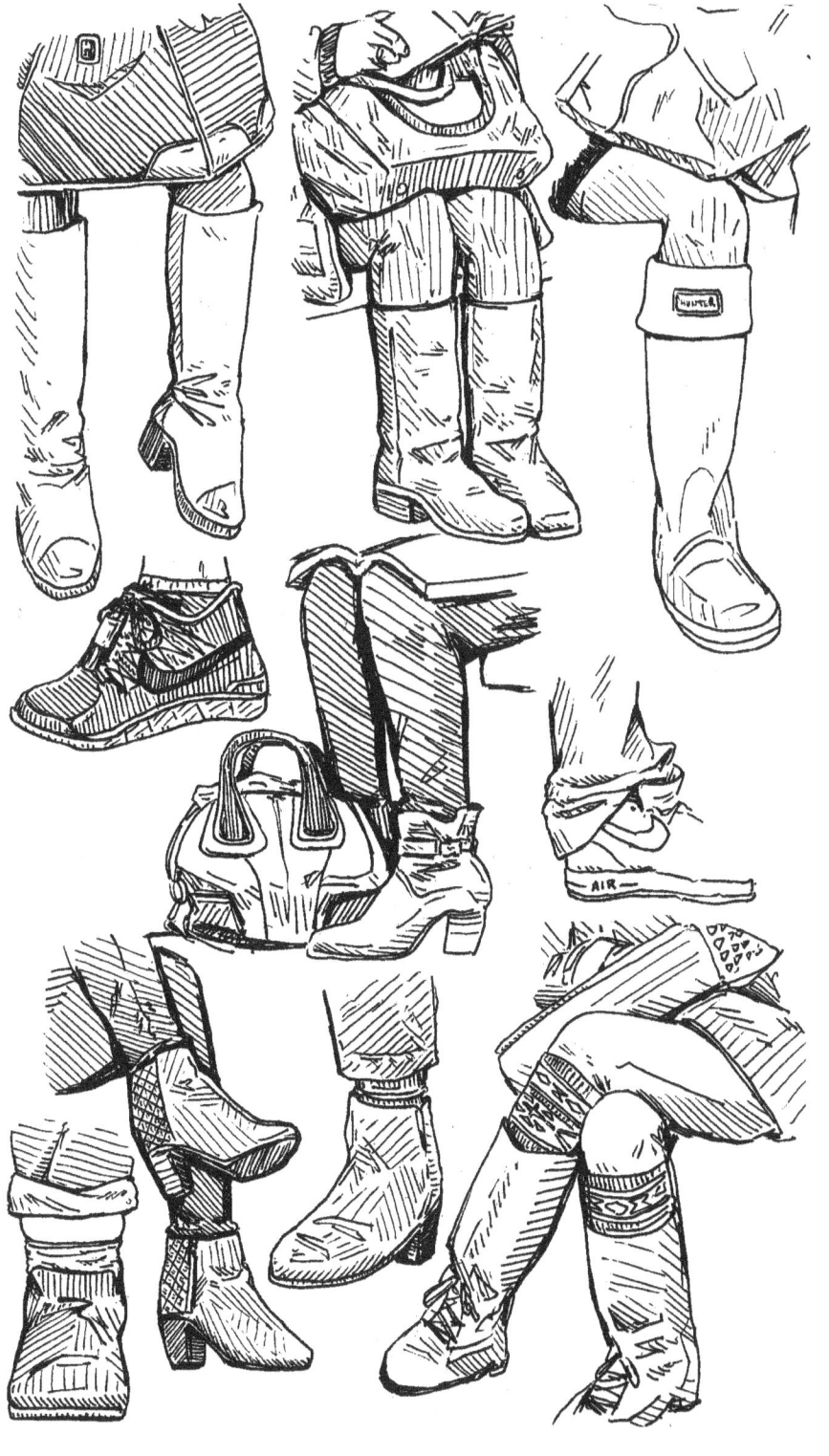

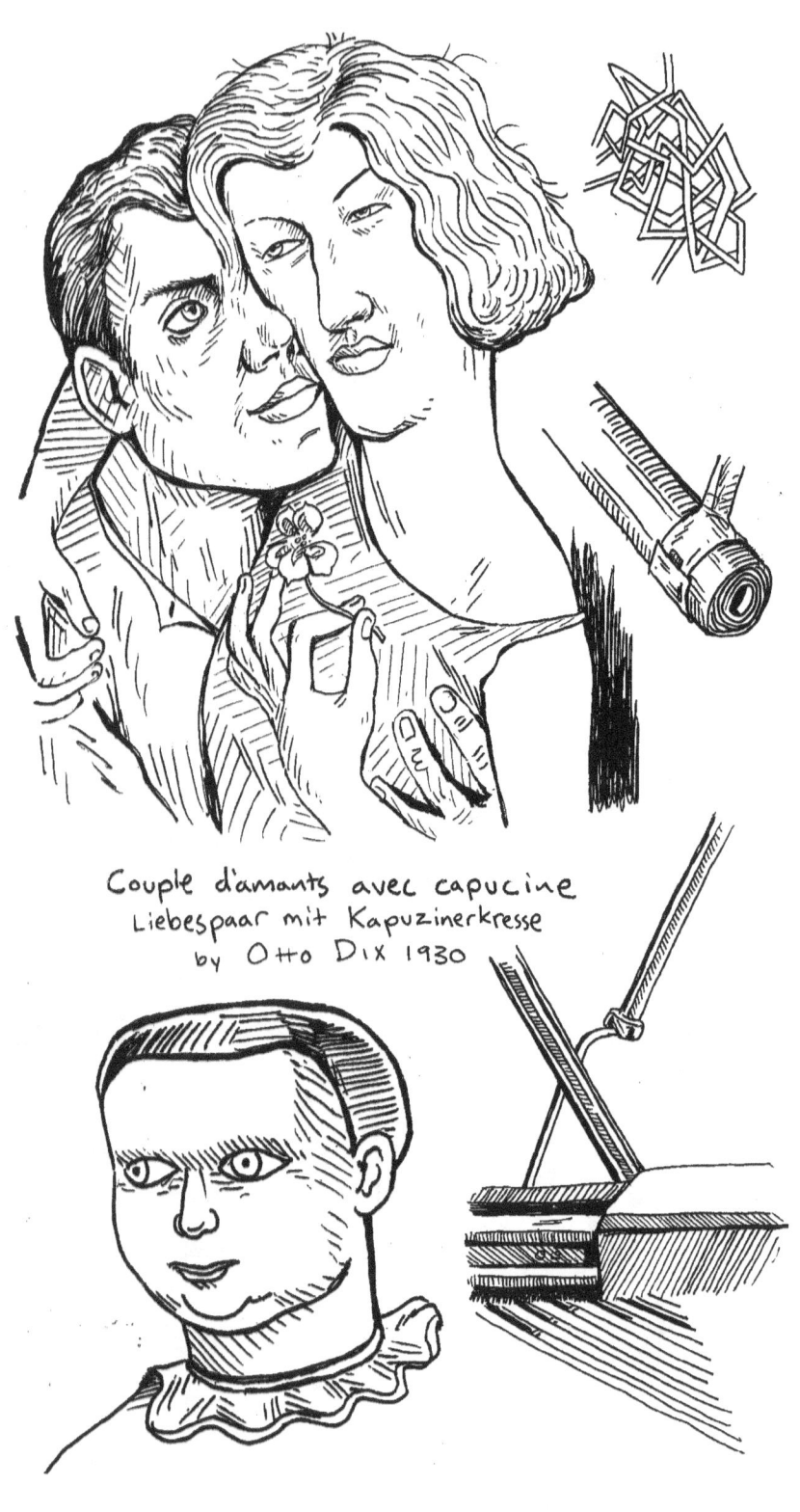

Couple d'amants avec capucine
Liebespaar mit Kapuzinerkresse
by Otto Dix 1930

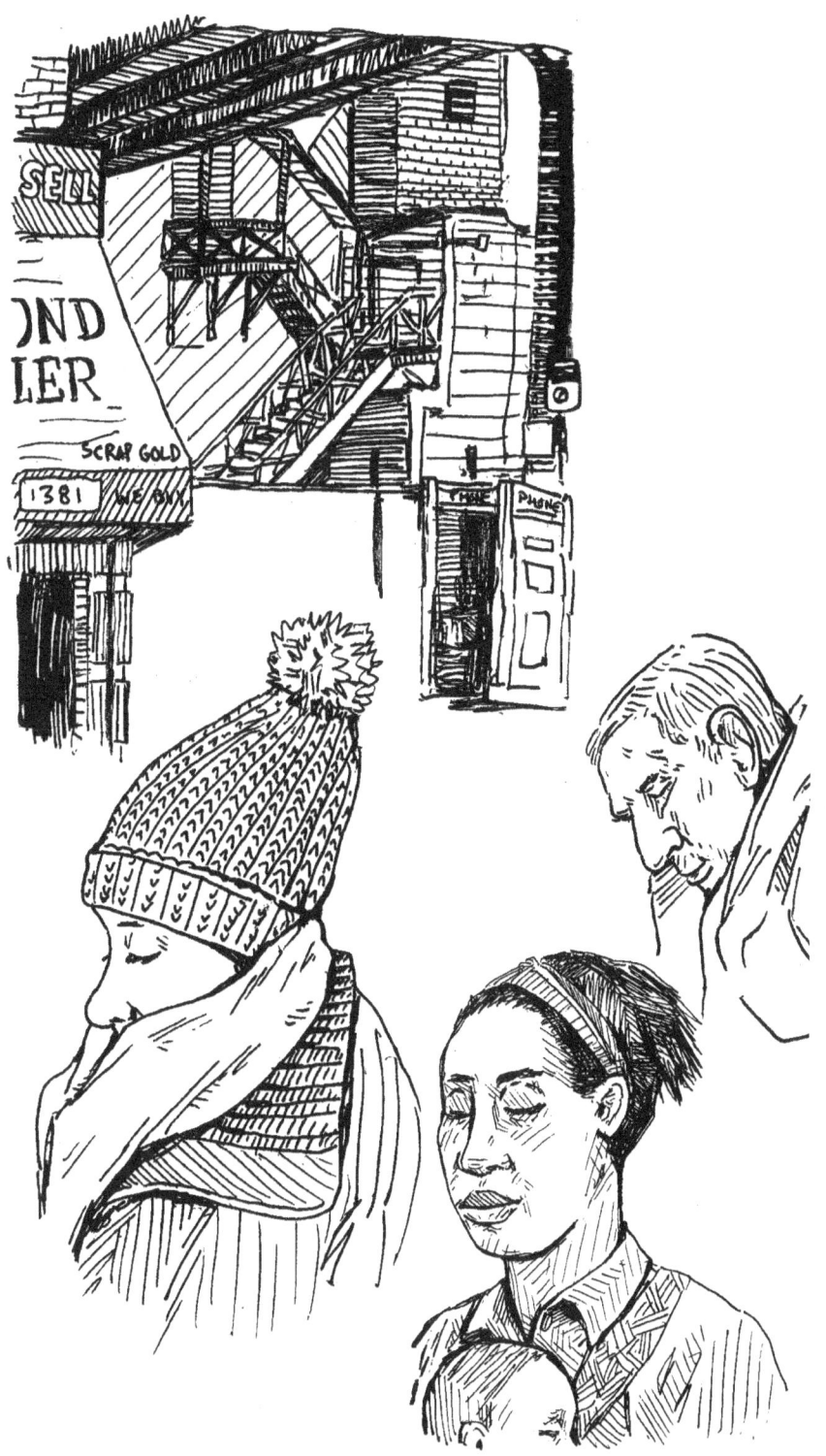

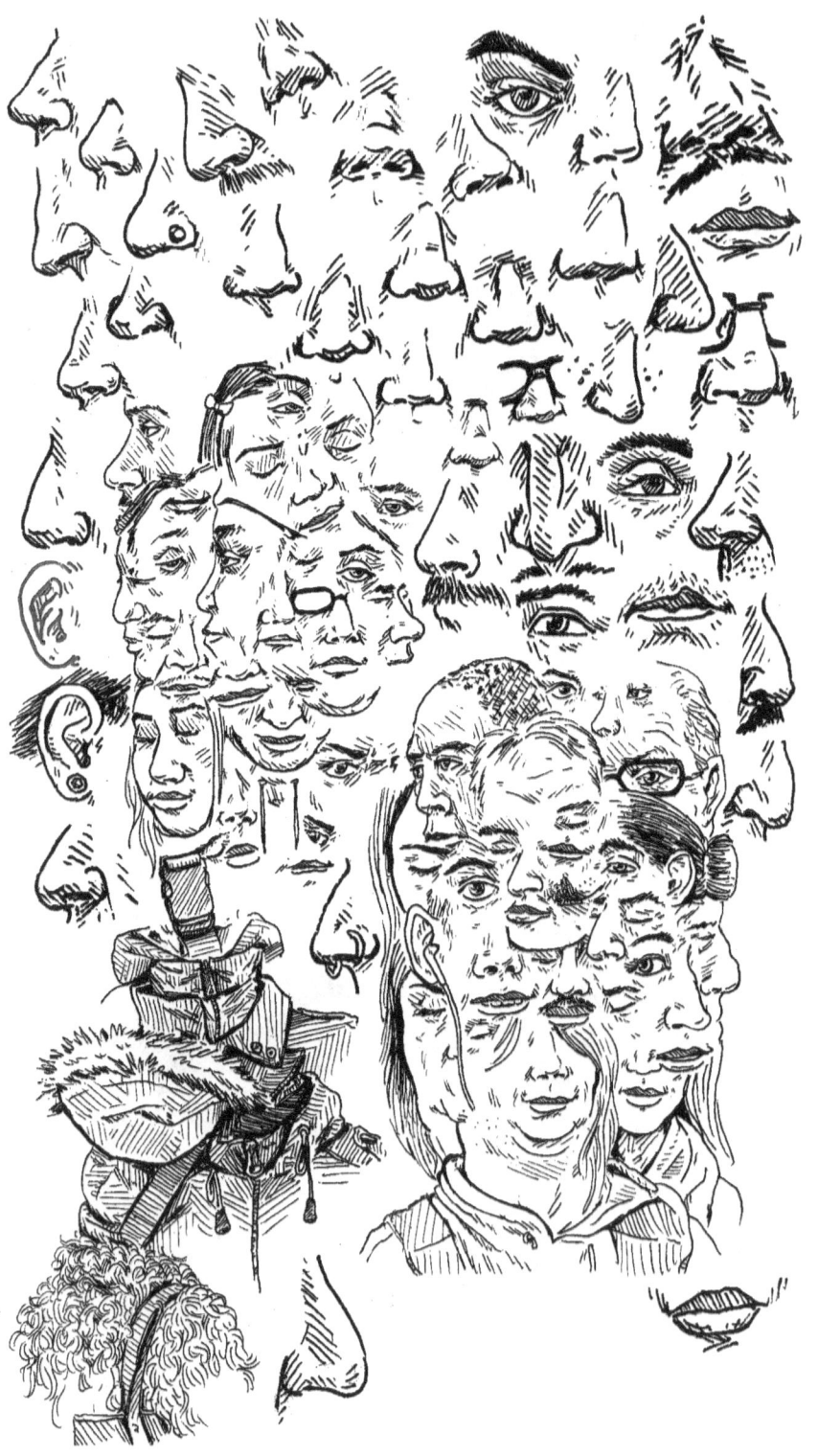

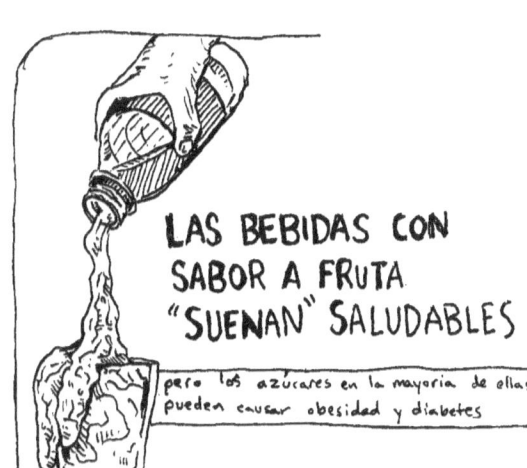

LAS BEBIDAS CON SABOR A FRUTA "SUENAN" SALUDABLES

pero los azúcares en la mayoría de ellas pueden causar obesidad y diabetes

EMERGENCY EYE/FACE WASH
LAVADO DE EMERGENCIA OCULAR/FACIAL
LAVAGE FACIAL ET OCULAIRE D'URGENCE

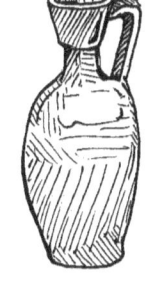

Jug
Ptolemaic, 332-30 B.C.
Faience
Rogers Fund, 1944 (44.4.44)

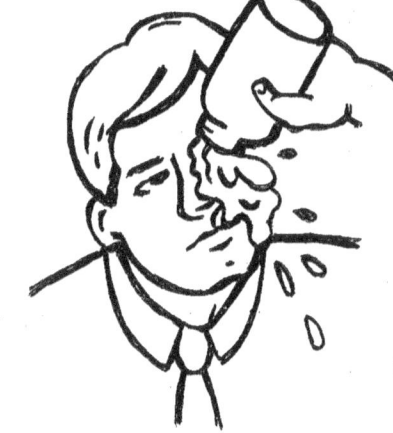

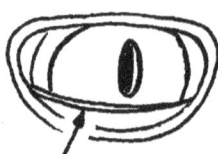 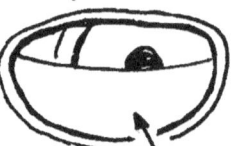

NICTITATING MEMBRANE OF SHARK

www.ingramcontent.com/pod-product-compliance
Lightning Source LLC
Chambersburg PA
CBHW020917180526
45163CB00007B/2778